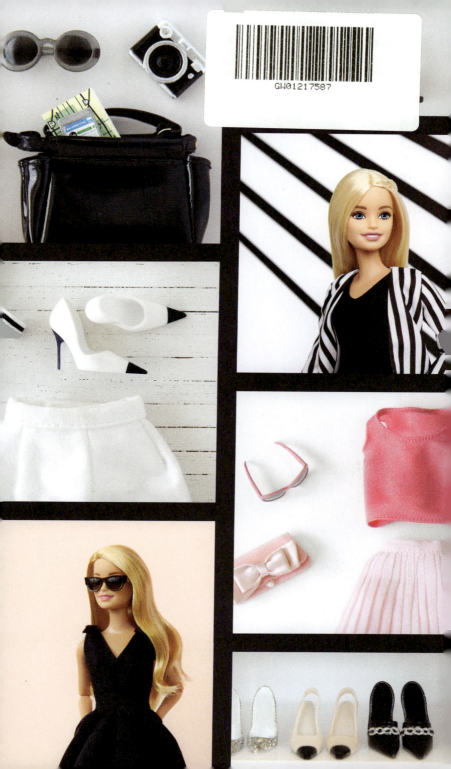

Design by Katie Benezra

ISBN 978-1-4197-3221-8

BARBIE and associated trademarks and trade dress are owned by, and used under license from, Mattel. ©2018 Mattel. All Rights Reserved.

Published in 2018 by Abrams Noterie, an imprint of ABRAMS. All rights reserved. No portion of this book may be reproduced, stored in a retrieval system, or transmitted in any form or by any means, mechanical, electronic, photocopying, recording, or otherwise, without written permission from the publisher.

Printed and bound in China
10 9 8 7 6 5 4 3 2 1

Abrams Noterie products are available at special discounts when purchased in quantity for premiums and promotions as well as fundraising or educational use. Special editions can also be created to specification. For details, contact specialsales@abramsbooks.com or the address below.

195 Broadway
New York, NY 10007
abramsbooks.com

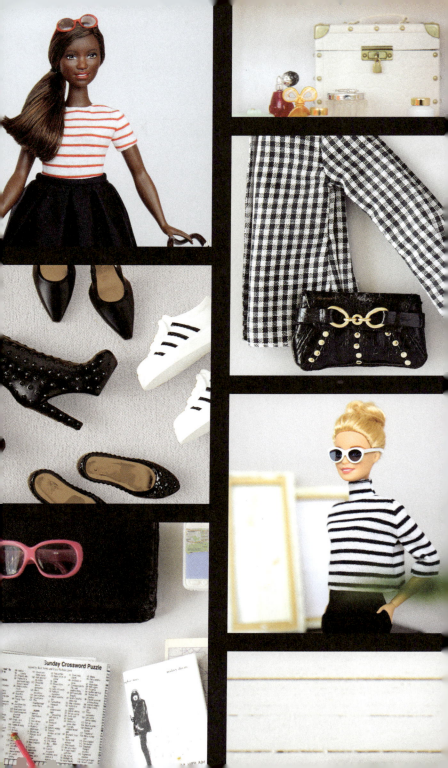